MIX YOUR OWN
WATERCOLORS

AN ARTIST'S GUIDE TO
SUCCESSFUL COLOR MIXING

JOHN LIDZEY

A QUINTET BOOK

Published by Walter Foster Publishing, Inc.
23062 La Cadena Dr.
Laguna Hills, California 92653

ISBN 1-56010-223-3

This book was designed and produced by
Quintet Publishing Limited
6 Blundell Street
London N7 9BH

Creative Director: Richard Dewing
Designer: Ian Hunt
Project Editors: Claire Tennant-Scull, Stefanie Foster
Photographer: Paul Forrester

Typeset in Great Britain by
Central Southern Typesetters, Eastbourne
Manufactured in Singapore by
Bright Arts (Pte Ltd)
Printed in China by
C&C Offset Printing Co., Ltd

CONTENTS

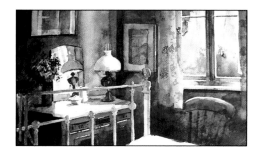

INTRODUCTION

Mixing colors is a practical activity, and although a knowledge of color theory is useful there is no substitute for the experience of testing, matching and experimenting with tubes or pans of paint.

Watercolors mix in a way that is special to them, not always in the way that color theory or even common sense might suggest. Many artists who are new to the medium are unprepared for this and are disappointed with the color mixing in their own paintings. Such people may find this book helpful, as may others who have more experience in watercolor painting.

The pages that deal with color mixing are devoted to the primary and secondary colors on the color wheel and with browns and neutrals. You may find this part of the book useful for reference purposes when you are painting or you may prefer to use it as a basis for further experiments of your own.

The dilution of colors plays an important part in color mixing. The color patches shown on the pages that follow have been mixed from tubes of artist's quality watercolor diluted with water to provide an even, fluid consistency – a "standard mix" or dilution. Some colors require more dilution than others to give the same coverage, and if you want to experiment, you should make a series of trial patches to determine the amount of water required in a mix.

Weak dilution or mix (more water)

Where color mixes are shown in this book, the proportions of the colors used to make each mix are indicated in terms of the number of brushfuls, or parts, of color. Combinations of colors are created from standard solutions of two colors. The new colors can then be used in weak, standard or strong dilutions as required. A weak dilution, or mix, is one using more water than a standard dilution, while a strong dilution uses less water, creating a more opaque effect.

Standard dilution

Strong dilution (less water)

In many cases the color patches show how mixing two colors

together will eventually produce a third – for example, a blue added to a brown will progressively produce gray. What might also be seen is the mottling or granulation that results from the mixing of two colors. You will discover that some colors readily combine with others to produce good, even washes, while other colors seem reluctant to mix evenly and will even tend to separate when laid down. Although it could be argued that such colors should be avoided, mixes using them can give watercolor that very quality that is so special to the medium.

The photographs of still lifes show possible subjects for the watercolorist. The main colors in each set-up are analyzed in terms of their constituent colors, and an appropriate breakdown is shown alongside indicating the proportions of each color used. Further practice can be gained by taking a color photograph from a magazine and by matching the colors in a similar way.

If you base your mixings on those in the following pages you may not be able to match exactly the resulting colors with the ones shown. This could be because of a difference in the manufacture or grade of watercolor you use, the nature of the paper you use or even the kind of light under which you view comparisons. However, the color patches shown should give you a completely satisfactory guide to the results you can expect.

An infinite variety of color mixes can be created from even a simple palette.

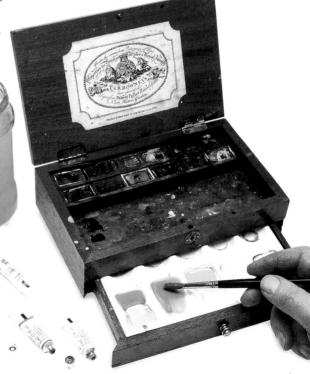

COLOR TERMS AND THEORY

Before you begin to mix colors it is useful to have some idea of the general principles of color and to be familiar with some of the descriptive terms which are used. It can be helpful to know how colors relate to one another and how they might be manipulated to produce the results you intend. Colors bought from an art shop or mixed from others may be described in three different ways.

HUE

The color of a paint can be identified by its hue – that is, red, gray, green or brown, and so on.

TONE

This term refers to the lightness or darkness of a color. Yellow is usually light in tone; black is dark in tone. The tone of a color can be lightened by adding Chinese white or, more normally, extra water.

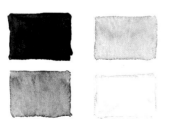

All colors can be lightened by adding water, as has been shown here.

INTENSITY

Bright colors, like some oranges and yellows, are said to have a high intensity, while others, like most browns and grays, are usually of low intensity. The intensity of colors can be diminished by the addition of a small amount of black or of a complementary color.

A color can be described by its intensity – that is, by its brightness or dullness. Red has a high intensity; brown has a low intensity.

WARM AND COOL COLORS

Nearly all colors may be seen as warm or cool. However, some colors have their own temperature scale. For example, there are warm and cold blues – compare French ultramarine with monestial blue.

Red is warm and blue is cool, but even blue colors may be distinguished by their degree of warmth.

THE COLOR WHEEL

A simple color wheel shows how basic colors relate to each other. Red, for example, is opposite to green, which means that red is the complementary of green. In the same way violet is the complementary of yellow.

Colors that are adjacent to each other in the color wheel are called analogous colors. Red and orange are analogous, as are a close-matching yellow and green.

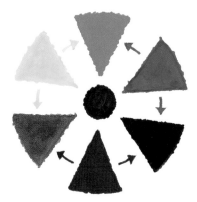

This shows how primary colors mix to make secondaries. Mix them all together and a dark, neutral color results (center).

PRIMARY COLORS

The primary colors are red, blue and yellow. They cannot be mixed from other colors, but they are the basis from which other colors can be mixed.

SECONDARY COLORS

The secondary colors result from the mixing of two primaries. If you look at the color wheel you will see that the primaries red and yellow make orange, that blue and yellow make green, and that red and blue make purple.

NEUTRAL COLORS

Black, white, and gray are called neutral colors. Often, however, they contain traces of another color – for example, you may see a greenish-gray or a warm reddish-black.

Blacks, grays, and white are referred to as neutral colors. Some neutrals may have a small amount of color in them — a greenish-gray or a reddish-black, for example.

Any hue may be progressively neutralized by adding increasing amounts of black or a complementary color. (See the color wheel.)

THE USE OF WATER IN MIXING COLOR

When you are painting, the colors you mix will, of course, be determined by the pigments you use, but another important ingredient in the mix is water. The range of any color can be extended from its darkest tone right through to the lightest of tints simply by adding water.

When it is applied to paper a weak mixture with plenty of water will allow the whiteness of the paper to show through. Even fairly strong mixes of watercolor will never be entirely opaque, but it is possible to produce strong colors in your paintings by building them up so that two, three, or even more colors are laid on top of one another. Remember to allow each layer to dry before applying the next. Always avoid using color in a concentrated form with only the smallest amount of water. If you do, your painting will not look like a watercolor and your pigments could develop an unpleasant shiny surface.

TRANSLUCENT COLORS

Much of the beauty of watercolor comes from the delicacy of overlaid watery washes. It is this quality of translucency that allows colors to be created on the paper rather than on the palette. For example, paint a small area of light blue watercolor, allow it to dry, and then paint over the top with a yellow. Where the two colors overlap a delicate green will result.

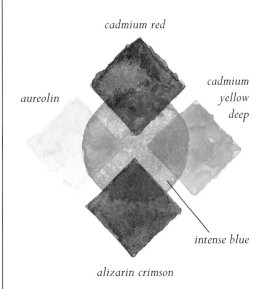

cadmium red

cadmium yellow deep

aureolin

intense blue

alizarin crimson

See how overlaid colors change their hue.

Some painters exploit this characteristic of watercolor to produce works of great beauty, with the quality rather like stained glass. If you want to paint in this way it is important that your color mixes are made with generous amounts of water.

Backruns like these can be a blessing or a curse. In many cases such marks can give watercolors a free, loose quality that is unmatched by any other medium.

GRANULATION

It is possible to achieve beautiful and extremely even washes with watercolor, but it sometimes happens that a pigment will precipitate, or separate, especially when the wash contains plenty of water. The resulting effect is an uneven, speckled texture, which can be quite interesting. Colors that are likely to do this are cerulean, French ultramarine blue, burnt umber, vermilion, raw umber, and yellow ochre.

the watercolor and creates a range of graded color effects. The results are always unpredictable, but it is this quality that can give the watercolor medium its special magic.

This broken surface of a wash is typical of granulation. Some colors will react in this way when they are mixed with large amounts of water.

WATER INTO PAINT

Watercolor can produce perfectly even and flat areas of pure color that have a special kind of beauty, but wonderful effects are possible, too, when clean water is added to a wet painted surface. Doing this breaks up

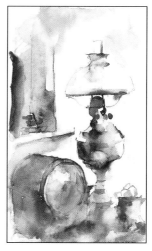

Unintentional effects of water often create wonderful images.

MIXING YELLOWS

WARM AND COOL

Yellow is one of the lightest colors in your palette, and it can be the easiest to change. Often, just a small amount of blue can change it to green, and it is usually easy to alter yellow to orange by adding the tiniest amount of red.

Many subtle variations of yellow can be achieved either by mixing two yellows together or by mixing a yellow with an analogous or complementary color. Because yellows are usually so delicate, however, great care must be taken when adding other colors so that the yellow hue is not lost altogether. Often, adding more than 10 percent of another color is sufficient to alter a yellow so that it loses its yellowness.

Greenish-yellows may be said to be cool, while orange-yellows can be described as warm. The mixes shown here demonstrate this.

The amounts of color to be mixed together are indicated in brushfuls, or parts, of paint.

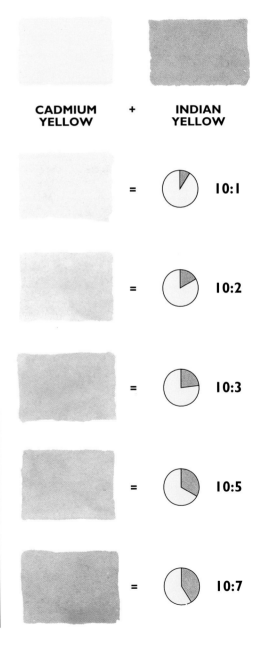

CADMIUM YELLOW + **INDIAN YELLOW**

= 10:1

= 10:2

= 10:3

= 10:5

= 10:7

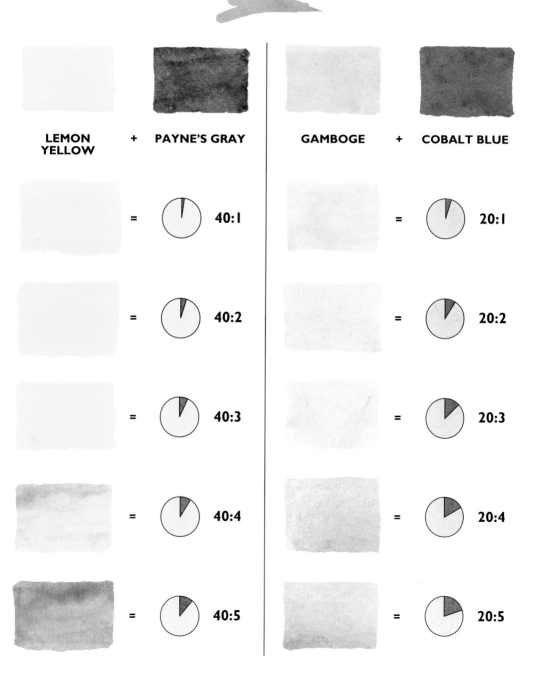

LEMON YELLOW	+	PAYNE'S GRAY		GAMBOGE	+	COBALT BLUE
	=	40:1			=	20:1
	=	40:2			=	20:2
	=	40:3			=	20:3
	=	40:4			=	20:4
	=	40:5			=	20:5

YELLOWS IN STILL LIFE WITH WATERING CAN

The yellows in this still life create some surprises. Some of them are both tonally darker and more orange than might be expected. Indeed, the yellows in the shade of the jug, melon and lemon might be described as "brownish."

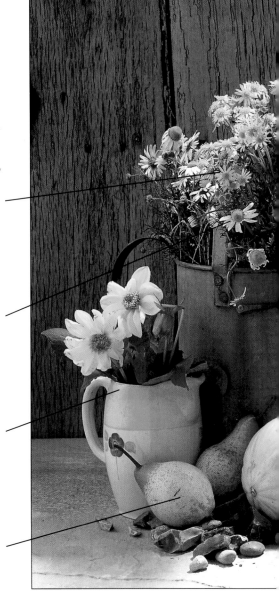

13 cadmium lemon
4 cadmium yellow
 deep
1 French
 ultramarine blue
2 cadmium red
standard dilution

17 gamboge
3 phthalocyanine
 blue
weak dilution

11 lemon yellow
2 cadmium orange
3 burnt umber
4 Naples yellow
standard dilution

12 aureolin
3 indigo
4 vermilion
1 cadmium yellow
 deep
standard dilution

Altering the proportion of colors in a yellow mix will change its hue, but increasing or decreasing the amount of water used will have an effect on the depth of tone of the color.

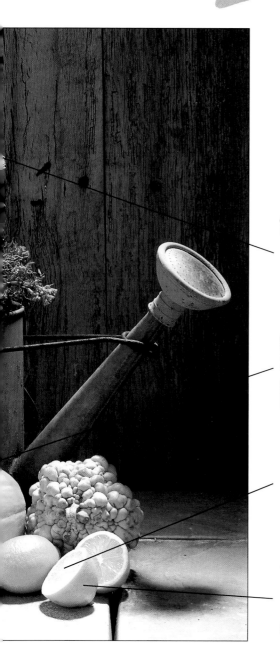

13 cadmium lemon
7 vermilion
weak dilution

12 lemon yellow
6 burnt umber
2 cadmium red
very weak dilution

14 aureolin
2 indigo
1 Payne's gray
3 vermilion
very weak dilution

10 lemon yellow
6 burnt umber
3 cadmium red
1 French
ultramarine blue
standard dilution

MIXING ORANGES

There is no cool version of orange. A cool orange would in fact look more like brown. A true orange would be either a red/orange or a yellow/orange.

RED/ORANGE

Red/orange colors can be mixed from both warm and cold reds and a wide range of yellows, but the strongest and most intense orange is mixed from a warm red and yellow – for example, vermilion and cadmium yellow. Red is the dominant partner in the mix, and it is, therefore, usually better to add red to yellow. Adding extra red will, of course, produce a redder orange.

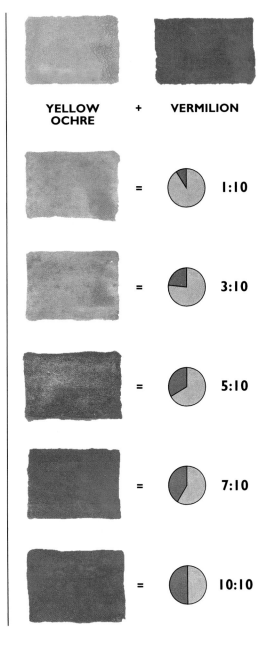

YELLOW OCHRE + **VERMILION**

= 1:10

= 3:10

= 5:10

= 7:10

= 10:10

INDIAN YELLOW	**+**	**CADMIUM RED DEEP**	
=	1:10		
=	2:10		
=	3:10		
=	4:10		
=	5:10		

LEMON YELLOW	**+**	**ALIZARIN CRIMSON**	
=	1:10		
=	2:10		
=	3:10		
=	4:10		
=	5:10		

MIXING ORANGES

YELLOW/ORANGE

It is possible to purchase proprietary yellow/orange colors – cadmium orange, for example – but because this color is so easy to mix, many watercolorists leave it out of their palettes. The most intense yellow/orange is mixed with a warm yellow such as cadmium yellow deep and the smallest amount of warm red. Make sure that you use a clean brush and that the mixing surface is clean, otherwise this color will become easily degraded and lose its intensity.

A softer yellow/orange may be mixed using a cool yellow, such as lemon yellow, as a base.

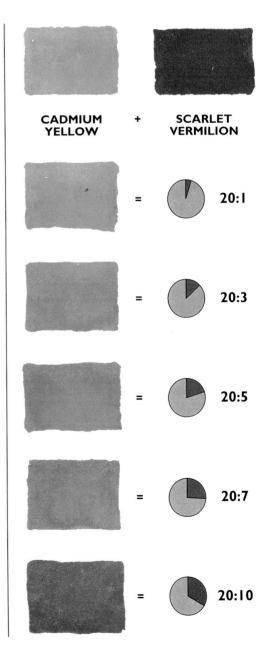

CADMIUM YELLOW + **SCARLET VERMILION**

= 20:1

= 20:3

= 20:5

= 20:7

= 20:10

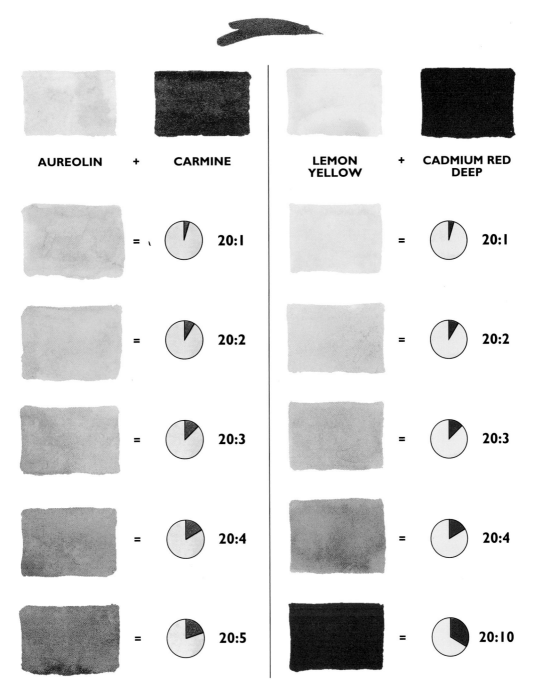

AUREOLIN	+	CARMINE		LEMON YELLOW	+	CADMIUM RED DEEP
=	20:1			=	20:1	
=	20:2			=	20:2	
=	20:3			=	20:3	
=	20:4			=	20:4	
=	20:5			=	20:10	

ORANGES IN STILL LIFE WITH FRUIT

The various orange colors in this photograph are slightly duller and darker than may be expected.

To test this, take a piece of white paper and cut a square out of it measuring about ¼ x ¼ in. Lay the paper on the photograph with the hole over the shaded area of one of

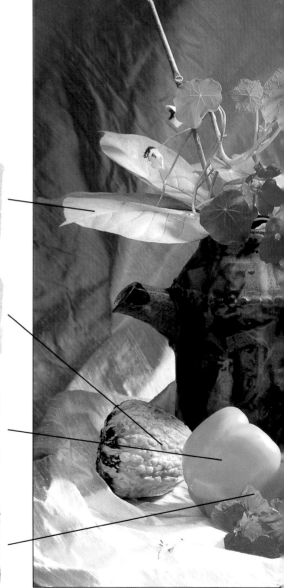

18 yellow ochre
2 cadmium red
trace of Payne's gray
weak dilution

14 cadmium yellow
 deep
6 cadmium red
weak dilution

14 cadmium orange
5 burnt umber
1 cadmium yellow
 deep
standard dilution

12 carmine
8 cadmium yellow
 deep
standard dilution

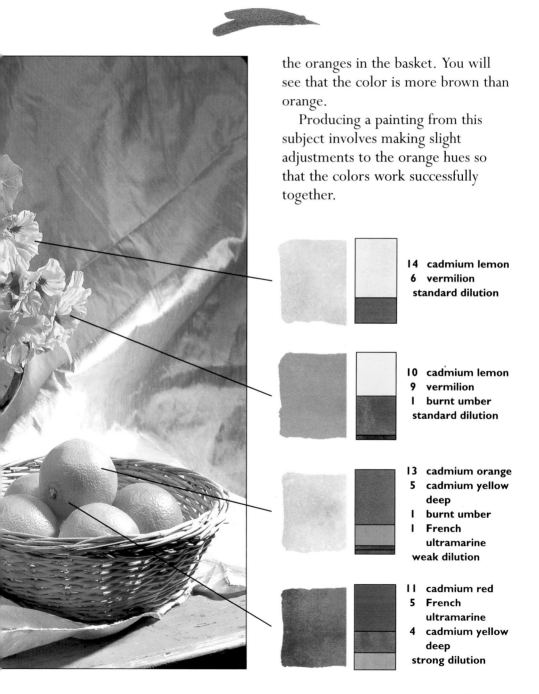

the oranges in the basket. You will see that the color is more brown than orange.

Producing a painting from this subject involves making slight adjustments to the orange hues so that the colors work successfully together.

14 cadmium lemon
6 vermilion
standard dilution

10 cadmium lemon
9 vermilion
1 burnt umber
standard dilution

13 cadmium orange
5 cadmium yellow deep
1 burnt umber
1 French ultramarine
weak dilution

11 cadmium red
5 French ultramarine
4 cadmium yellow deep
strong dilution

GALLERY – YELLOW AND ORANGE

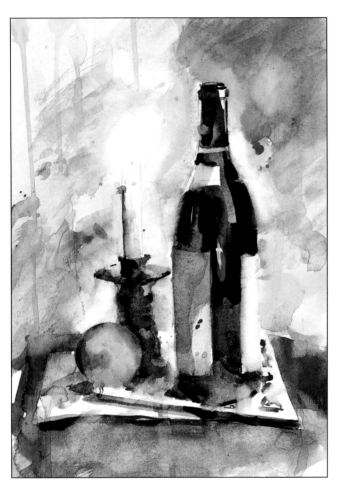

BELOW *The sunflowers in this painting by Elizabeth Harden are warm yellow, almost orange. Most of the leaves are yellow with a hint of green, which means that the color of the leaves and flowers work together. Notice how the colors have been kept under tight control: yellow can be very intense but the artist has very slightly neutralized the colors to avoid a glaring effect.*

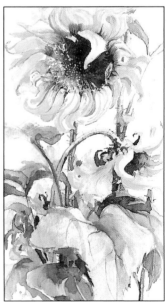

ABOVE *The background for this painting was made up from a variety of yellows: Yellow Ochre, Cadmium Yellow, Lemon Yellow and Aureolin. The colors were mixed on the paper together with amounts of Cadmium Red and French Ultramarine Blue. The effect is chaotic, but interesting painterly effects can be achieved by working this way. (John Lidzey)*

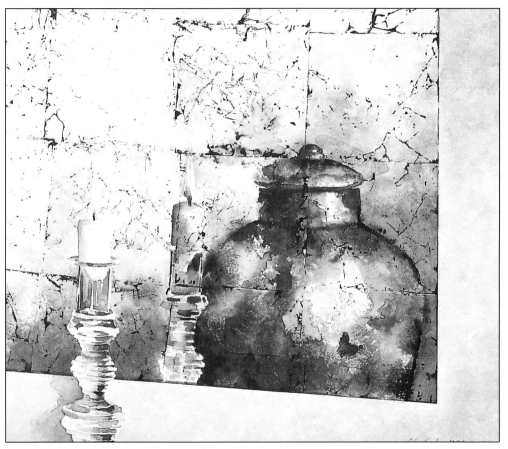

ABOVE This mysterious picture by Crin Gale makes very clever use of intense red/oranges and yellow/oranges set against hues of a much lower intensity. Gamboge, Raw Sienna and Burnt Umber have provided the base for the orange parts of the copper vase, and water has been carefully used to vary the tonal values over the surface area.

MIXING REDS

Many reds in tubes and pans are available to the watercolorist, but it is surprising how seldom one of these proprietary reds on its own will be suitable in a painting. Almost invariably the hue will need to be altered, and often, too, its intensity will need to be reduced. This can be achieved by adding a very small amount of its complementary color, green.

WARM REDS

A warm red will incline towards an orange. Therefore, adding yellow to a red will nearly always cause it to become warmer. Even adding a yellow to a cold red such as alizarin crimson will generate a warmer color, although it will lose intensity.

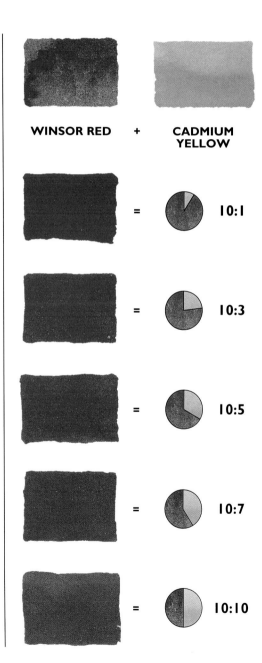

WINSOR RED + **CADMIUM YELLOW**

= 10:1

= 10:3

= 10:5

= 10:7

= 10:10

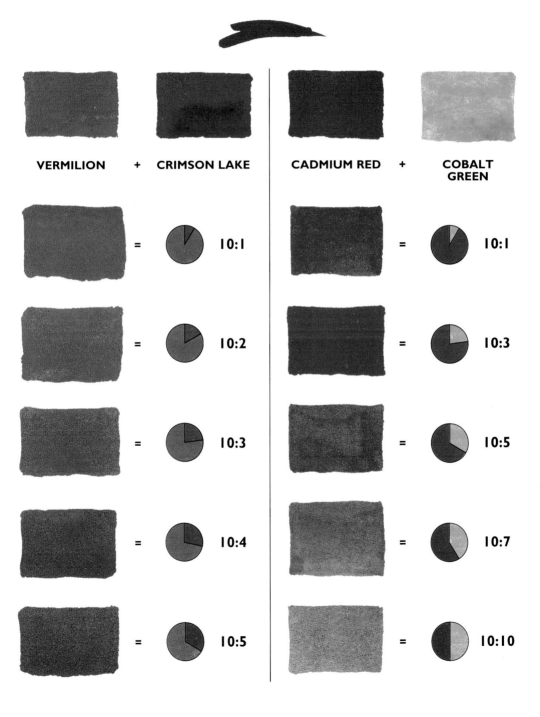

VERMILION	+	CRIMSON LAKE		CADMIUM RED	+	COBALT GREEN
	=	10:1			=	10:1
	=	10:2			=	10:3
	=	10:3			=	10:5
	=	10:4			=	10:7
	=	10:5			=	10:10

MIXING REDS

COOL REDS

Carmine is an example of a proprietary cool red, and alizarin crimson and rose madder are others. It is seldom possible to mix blues with warm reds to produce a cooler hue. Adding cerulean blue to permanent red, for example, will produce a cooler red, but it will lose its intensity and will become somewhat dirty. Many other mixes of warm reds and blues will produce near browns or other degraded colors.

Mixing blues to cool reds will usually cause them to become colder without any loss of intensity. Carmine and ultramarine blue, for example, will work well together. Notice the strength of scarlet lake and the relative weakness of alizarin crimson.

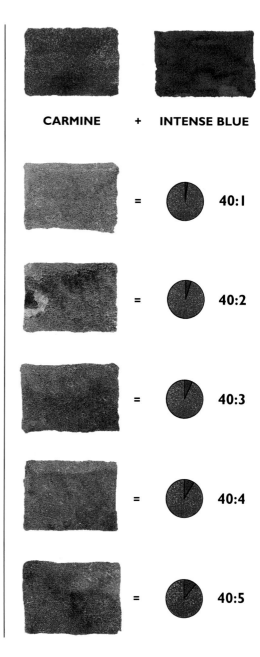

CARMINE + INTENSE BLUE

= 40:1

= 40:2

= 40:3

= 40:4

= 40:5

SCARLET LAKE + CERULEAN			SCARLET LAKE + ALIZARIN CRIMSON		
	=	10:1		=	10:1
	=	10:3		=	10:3
	=	10:7		=	10:7
	=	10:10		=	10:10
	=	10:15		=	10:15

REDS IN STILL LIFE WITH BOOKS

At first sight the range of reds in this arrangement seems rather narrow, but on closer inspection it can be seen that it extends from the violet/red on the bottle cap to orange/red on parts of the basket. Some of the reds are identical – the eggs in the basket and the beads on the book, for

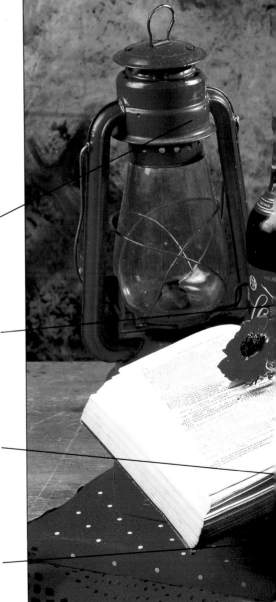

18 scarlet lake
1 phthalo blue
1 Payne's gray
standard mix

10 purple madder
10 cadmium red
strong mix

16 alizarin crimson
2 vermilion
2 phthalocyanine
 blue
standard mix

18 cadmium red
 deep
2 French
 ultramarine blue
standard mix

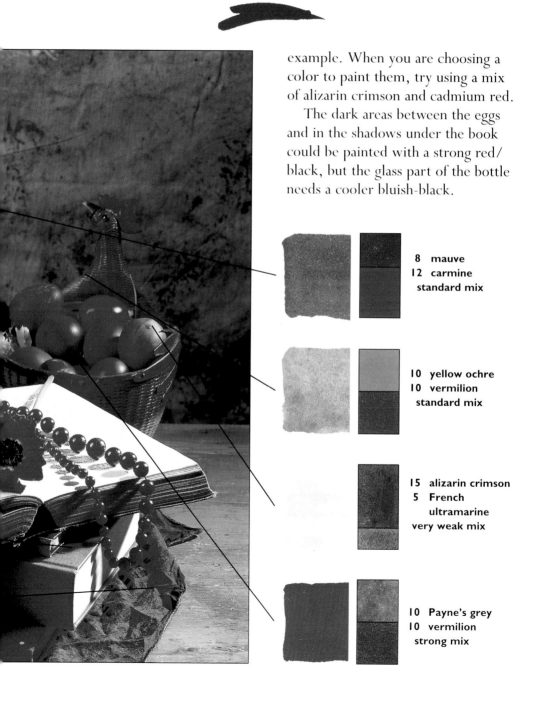

example. When you are choosing a color to paint them, try using a mix of alizarin crimson and cadmium red.

The dark areas between the eggs and in the shadows under the book could be painted with a strong red/ black, but the glass part of the bottle needs a cooler bluish-black.

8 mauve
12 carmine
standard mix

10 yellow ochre
10 vermilion
standard mix

15 alizarin crimson
5 French
ultramarine
very weak mix

10 Payne's grey
10 vermilion
strong mix

GALLERY – RED

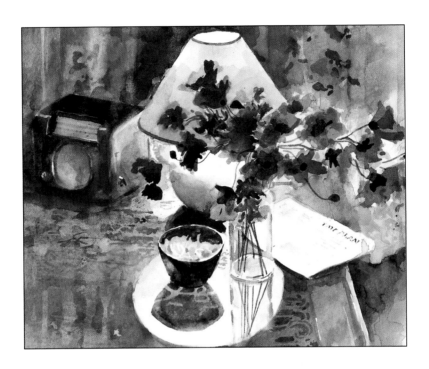

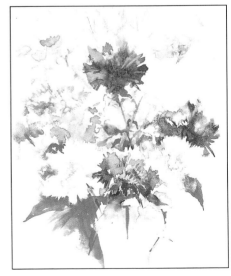

ABOVE *It is possible to mix very low intensity degraded reds and combine them with brighter and purer colors. These imitation poppies were painted in mixes of Carmine and Indigo with the addition of Payne's Gray for the very dark centers. The table was painted with a mix of Carmine, Ultramarine Blue, Yellow Ochre, and Payne's Gray. (John Lidzey)*

RIGHT *You can see how most of the reds in this painting by Elizabeth Harden are tending towards orange. Vermilion and Cadmium Red are examples of warm, orangish reds. It might be tempting to use such reds straight from the tube without any mixing, but in most cases this will produce an over-bright dazzling effect. Consider slightly neutralizing your reds with a comp-lementary color, or use water to reduce their strength.*

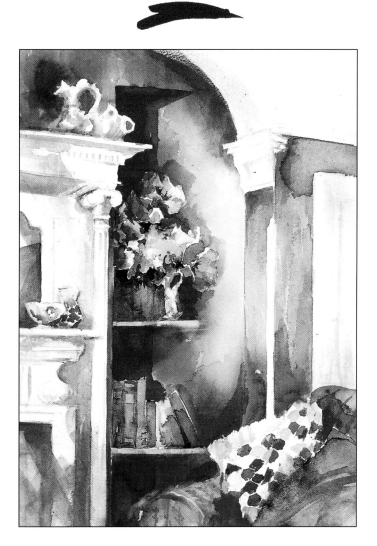

ABOVE This painting by Elizabeth Harden shows the use of
beautiful cool violet / reds. These are combined with the
delicate violet colors on the mantelpiece, while the overlaying
of colors wet-on-dry has produced a variety of color and tonal
effects. The addition of blue or violet to the mix has subtly
changed the red wall to a deep violet under
the bottom shelf.

MIXING VIOLETS

Blue combined with red produces violet. When a bright, intense violet is required it is better to select one from the proprietary range. Mixtures of reds and blues can lack their intensity.

WARM VIOLETS

The more blue that is added to the red, the colder the violet becomes. Thus carmine with only a small amount of ultramarine blue produces a warm violet, which becomes progressively colder as more blue is added. Cool proprietary violets can be warmed by adding red – for example, mauve can be considerably warmed by adding alizarin crimson.

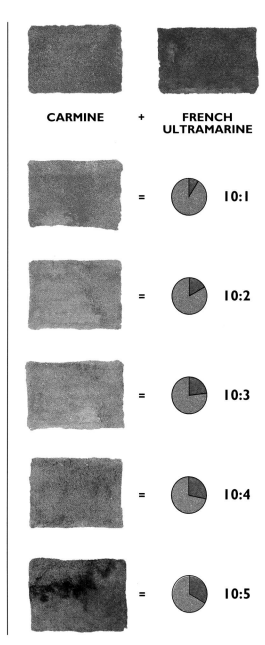

CARMINE + **FRENCH ULTRAMARINE**

= 10:1

= 10:2

= 10:3

= 10:4

= 10:5

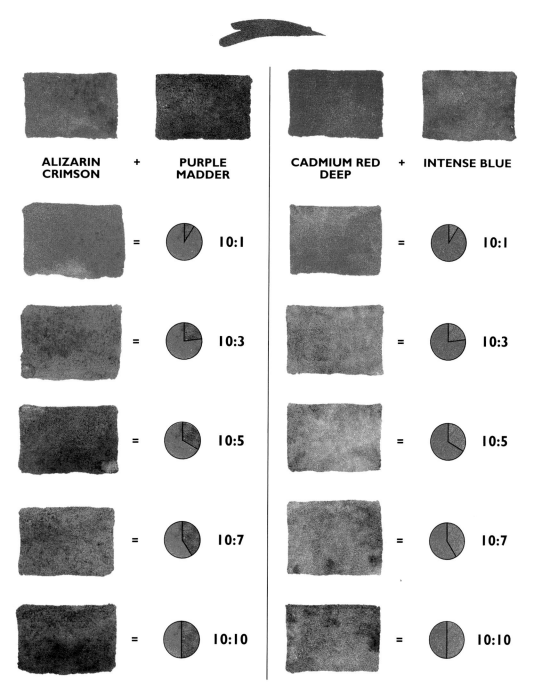

ALIZARIN CRIMSON	+	PURPLE MADDER		CADMIUM RED DEEP	+	INTENSE BLUE
=		10:1		=		10:1
=		10:3		=		10:3
=		10:5		=		10:5
=		10:7		=		10:7
=		10:10		=		10:10

MIXING VIOLETS

COOL VIOLETS

The best cool violets are mixed with cool reds. Intense blue and alizarin crimson can make a range of cool violets, as indeed can intense blue and carmine, although the amount of colors you use must be carefully controlled. The use of a Prussian blue in mixing violets is not normally recommended because its pigment can separate, producing a somewhat gritty result, especially in low grade watercolors. Low-toned violets can be produced by building up mixes, allowing each layer to dry between applications.

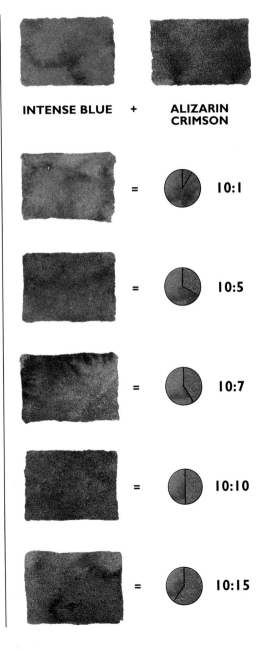

INTENSE BLUE + ALIZARIN CRIMSON

= 10:1

= 10:5

= 10:7

= 10:10

= 10:15

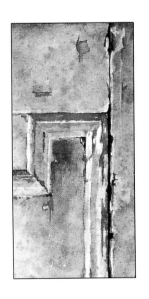

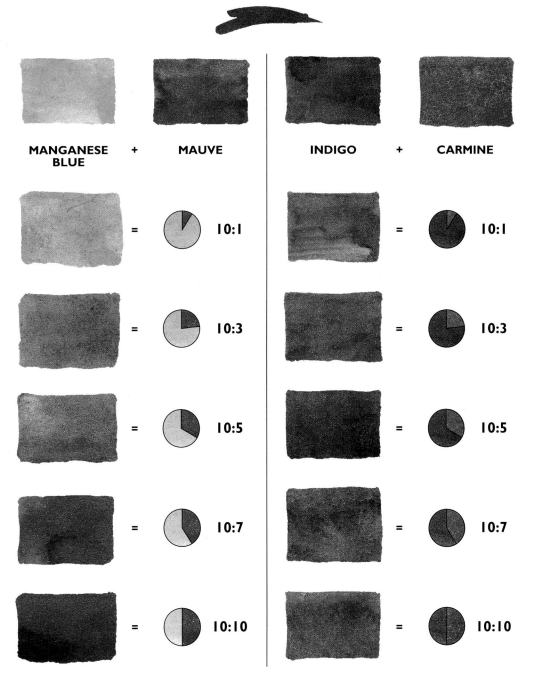

MANGANESE BLUE	+	MAUVE			INDIGO	+	CARMINE		
			=	10:1				=	10:1
			=	10:3				=	10:3
			=	10:5				=	10:5
			=	10:7				=	10:7
			=	10:10				=	10:10

GALLERY – VIOLET

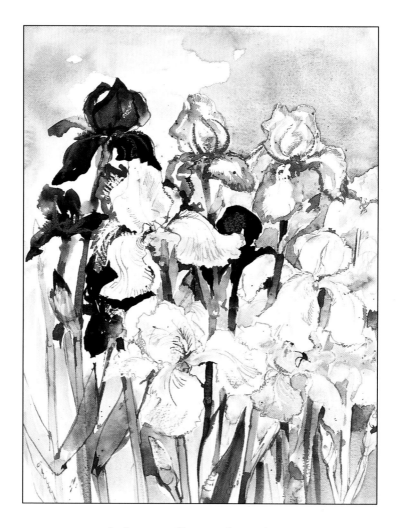

ABOVE *Rather unusually, in producing this painting,
Kay Ohsten has used the same color Mauve from two different
artists' paint manufacturers. The difference between the two
hues is quite distinct so that they are both a feature
of her paintbox. But to achieve variety of hue and tone,
Payne's Gray and small amounts of Alizarin Crimson were
used in the mixes.*

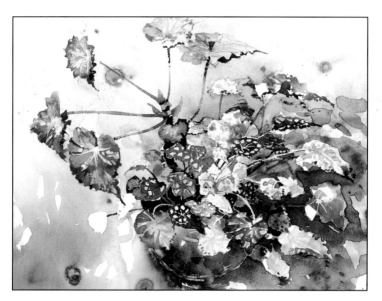

ABOVE Begonia leaves can show interesting violet hues together
with softer, more earthy colors. In this loosely painted sketch by
Kay Ohsten the background was brushed in mainly with
Magenta, Mauve, and Indigo while the violet and red/violet
leaves were painted using mixtures from Magenta, Mauve,
Alizarin Crimson, Permanent Blue, and French Ultramarine Blue.

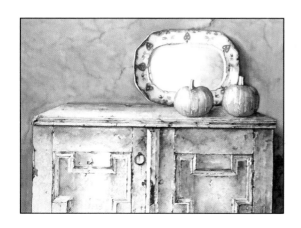

LEFT This beautiful and simple painting
by Crin Gale sets a pale violet cupboard
against a neutralized, complementary
background. The colors used for the
cupboard were French Ultramarine Blue,
Indian Red and Rose Madder. The
background was created from Burnt Umber
and Cobalt Blue. The tonal values on the
cupboard were achieved by carefully
controlling the paint density and by
building up the colors
wet-on-dry.

MIXING BLUES

There are many kinds of blue available to the watercolorist. Some blues – intense blue and Prussian blue, for example – are quite strong, but others – cerulean and cobalt, for instance – are relatively weak.

WARM BLUES

Although blue is regarded as a cold color it can be seen that some blues are warmer than others. A warm blue tends toward the color violet, while a cold blue tends to be slightly more greenish. Some proprietary blues can be warmed by adding a bluish-red to the mix. For example, the smallest amount of alizarin crimson added to French ultramarine blue will provide a warmer blue. Many other blues will become dirty, especially when they are mixed with a warm red.

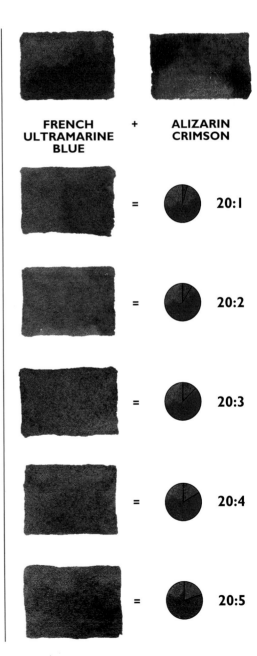

FRENCH ULTRAMARINE BLUE + **ALIZARIN CRIMSON**

= 20:1

= 20:2

= 20:3

= 20:4

= 20:5

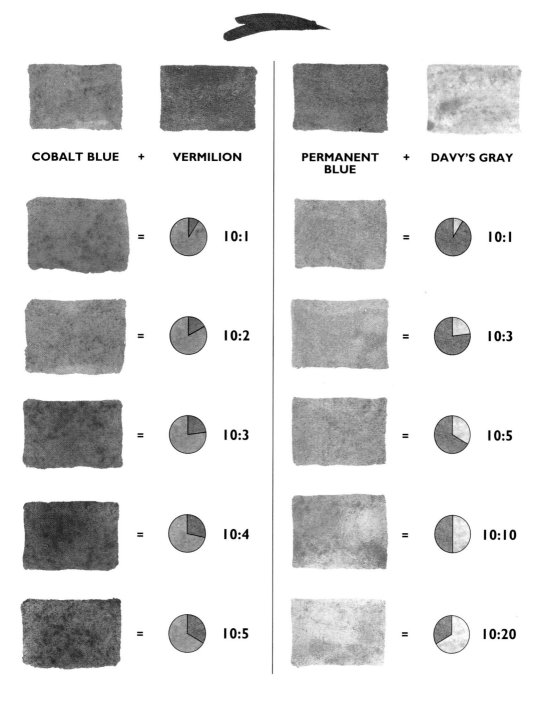

COBALT BLUE	+	VERMILION		PERMANENT BLUE	+	DAVY'S GRAY
	=	10:1			=	10:1
	=	10:2			=	10:3
	=	10:3			=	10:5
	=	10:4			=	10:10
	=	10:5			=	10:20

MIXING BLUES

COOL BLUES

Cool blues can be seen as being somewhat greenish or turquoise in hue, but slightly degraded blues might also be seen as cold. A mix of cobalt blue and raw umber will produce a quiet, cool blue, as will cerulean and vermilion. Adding the slightest amount of lemon yellow to French ultramarine blue will produce a useful cool blue.

The blues in your kit will not always provide the exact blue you need to match the blue in your subject, and you will often find that mixing two blues together will provide the color you need.

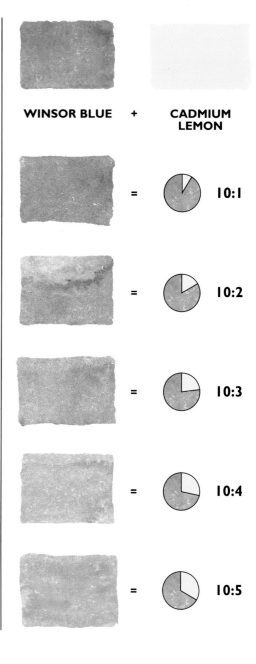

WINSOR BLUE + **CADMIUM LEMON**

= 10:1

= 10:2

= 10:3

= 10:4

= 10:5

INTENSE BLUE	**+** **PAYNE'S GRAY**	**FRENCH ULTRAMARINE BLUE**	**+** **LEMON YELLOW**

 = 10:1 = 10:1

 = 10:2 = 10:2

 = 10:3 = 10:3

 = 10:4 = 10:4

 = 10:5 10:5

BLUES IN STILL LIFE WITH BOTTLES

Some of the blues in this still life that seem so bright and pure are not quite what they seem: the cerulean blue, which was used for the pale parts of the scarf, needs slightly neutralizing with a complementary color; and the blue of the broken bottle in the foreground is of relatively low

16 **French ultramarine blue**
4 **indigo**
standard dilution

19 **cerulean blue**
1 **cadmium orange**
weak dilution

18 **phthalocyanine blue**
2 **Payne's gray**
standard dilution;
two applications
of color

7 **French ultramarine blue**
6 **yellow ochre**
7 **alizarin crimson**
weak dilution

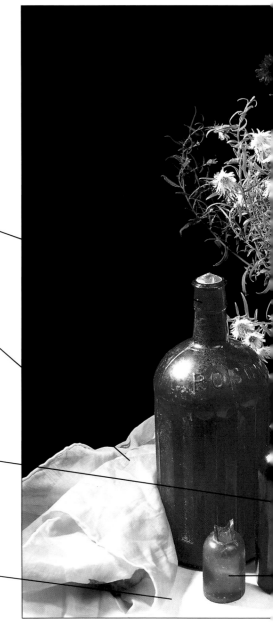

strength and requires similar treatment. The blue used for the lamp is cooler and slightly green. The manganese blue used in this mix does not cover the surface of the paper well, and it was necessary to apply two layers of paint to give sufficient depth of color.

10 alizarin crimson
10 French
ultramarine blue
standard dilution

18 manganese blue
1 alizarin crimson
1 phthalocyanine
blue
standard dilution;
two applications of
color

10 French
ultramarine blue
9 phthalocyanine
blue
1 Payne's gray
standard dilution

9 cobalt blue
9 French
ultramarine blue
1 cadmium red
1 aureolin
standard dilution

GALLERY – BLUE

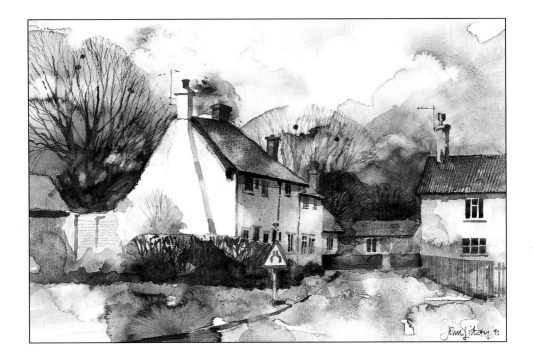

ABOVE Cool blues and violet/blues combine to create the impression of a cold winter's day. The sky was painted using mixes of French Ultramarine Blue, Intense Blue, Indigo and Alizarin Crimson. The foreground effects made use of Indigo and Aureolin (left) with Payne's Gray, Carmine and Yellow Ochre (right). The house shadows are Ultramarine Blue with a touch of Indigo. (John Lidzey)

RIGHT This painting is of an old fireplace in my studio. The walls are blue-gray and the fireplace is a faded white. The colors in the painting are a good match to the original. I built up the colors in a series of weak overlaying washes using Payne's Gray, Ultramarine Blue, Cadmium Yellow, Carmine and Yellow Ochre. Each wash was applied only after the previous one had dried. (John Lidzey)

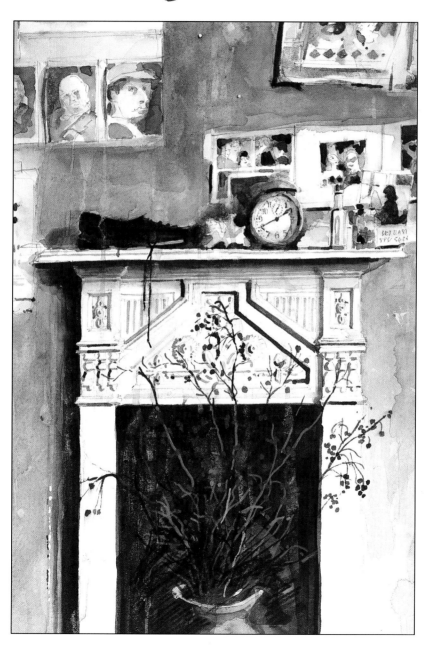

MIXING GREENS

There are relatively few proprietary watercolor greens produced, but it is not difficult to mix a wide range of greens from other colors, and many watercolorists prefer to work without a single green in their palettes.

WARM GREENS

A green may be said to be warm when it is yellowish. It is even possible to mix a green that contains a certain amount of red, although the resulting color will be rather dull and lacking in intensity. Warm greens can be mixed using cadmium yellow as a base, and mixing this color with cerulean produces a beautiful organic, if sometimes a somewhat patchy, green.

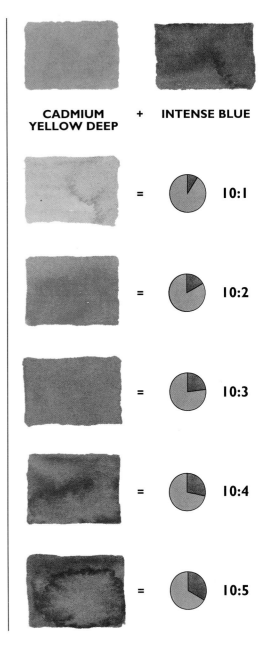

CADMIUM YELLOW DEEP + **INTENSE BLUE**

= 10:1

= 10:2

= 10:3

= 10:4

= 10:5

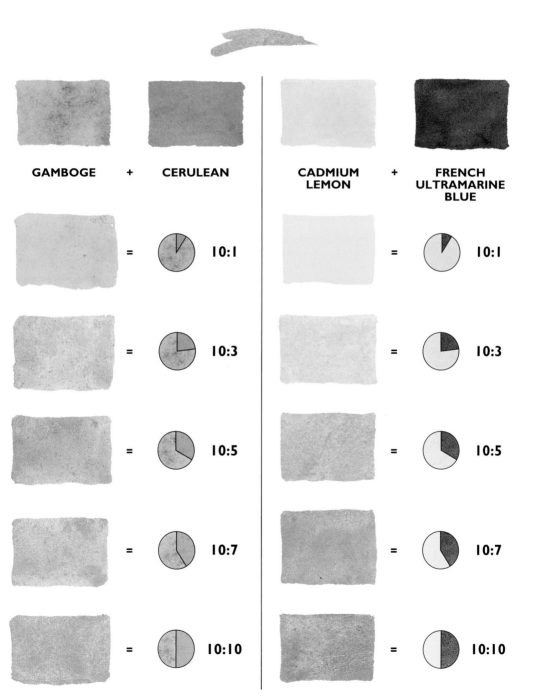

GAMBOGE + CERULEAN	CADMIUM LEMON + FRENCH ULTRAMARINE BLUE
= 10:1	= 10:1
= 10:3	= 10:3
= 10:5	= 10:5
= 10:7	= 10:7
= 10:10	= 10:10

MIXING GREENS

COOL GREENS

Hooker's green can be called cool (bluish), and sap green can be described as warm (yellowish). The intensity of both these colors is impossible to match with mixing, especially the cooler Hooker's green. It is, however, often better to mix a lower intensity (duller) green from yellow and blue. Beautiful blue/greens may be mixed from cool blues and yellows – lemon yellow and intense blue, for example, produce a wonderful cold green. Other possible combinations are shown here.

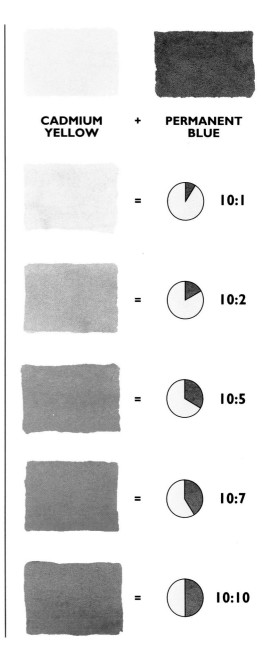

CADMIUM YELLOW + PERMANENT BLUE

= 10:1

= 10:2

= 10:5

= 10:7

= 10:10

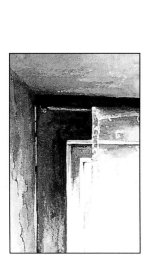

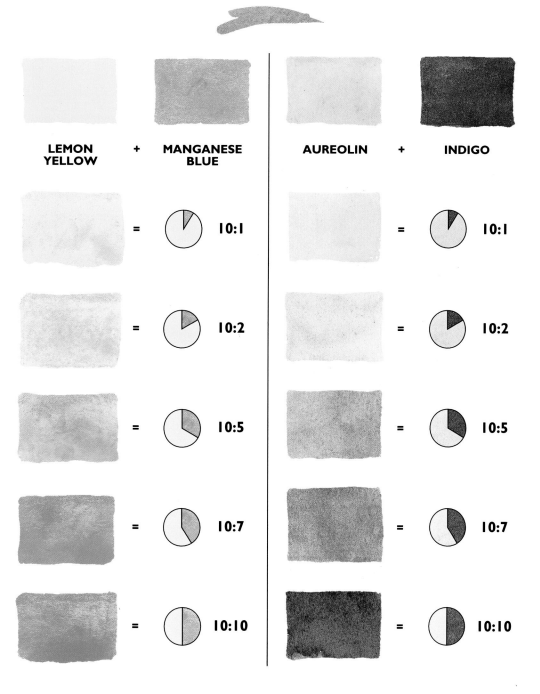

LEMON YELLOW	+	MANGANESE BLUE		AUREOLIN	+	INDIGO	
	=		10:1		=		10:1
	=		10:2		=		10:2
	=		10:5		=		10:5
	=		10:7		=		10:7
	=		10:10		=		10:10

GREENS IN STILL LIFE WITH FOLIAGE

This arrangement shows a number of lovely greens. Within the foliage the hues extend from the fresh yellow/green of the conifer on the right to the mysterious, low-toned blue/green of the Euphorbia on the left. When you are painting the tones of the Euphorbia the colors may be

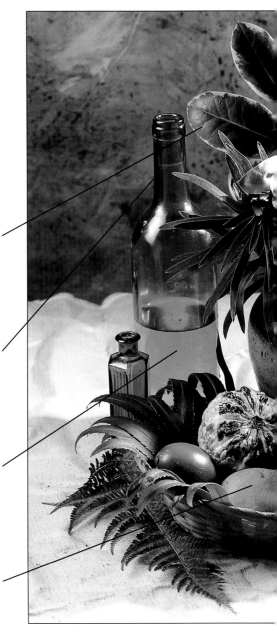

13 **French ultramarine blue**
6 **burnt umber**
1 **aureolin**
weak dilution

8 **phthalocyanine blue**
7 **indigo**
3 **lemon yellow**
2 **Payne's gray**
strong dilution

11 **lemon yellow**
8 **phthalocyanine blue**
1 **Payne's gray**
standard dilution

13 **cadmium yellow**
2 **French ultramarine blue**
5 **manganese blue**
standard dilution

adjusted to light and dark by mixing
additional water into the basic mix
for the lighter leaves or by adding
Payne's gray for the ones in shadow.

The color of the bottle on the
extreme left of the picture is
virtually the same as the color of the
liquid in the bottle next to it.

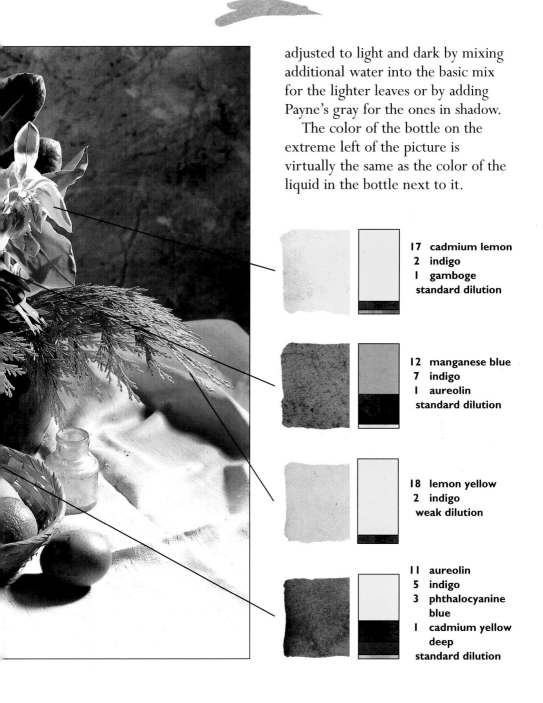

17 cadmium lemon
2 indigo
1 gamboge
standard dilution

12 manganese blue
7 indigo
1 aureolin
standard dilution

18 lemon yellow
2 indigo
weak dilution

11 aureolin
5 indigo
3 phthalocyanine
blue
1 cadmium yellow
deep
standard dilution

GALLERY – GREEN

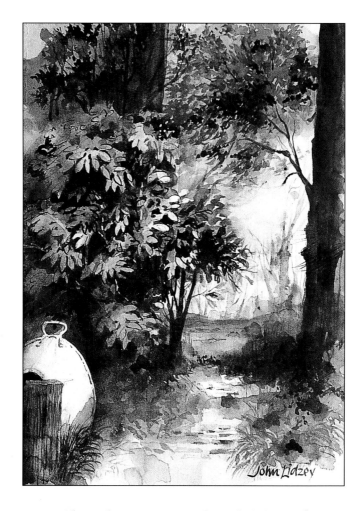

ABOVE *This garden scene was painted into the light. The foliage
in sunlight was painted in pale dilute greens, while the foliage in
shadow made use of a much stronger mix. The top right foliage
was painted in three stages, wet-on-dry. First: pure Cadmium
Yellow Deep; second: Cadmium Yellow Deep plus French
Ultramarine Blue; third: Indigo and Payne's Gray. The foliage on
the left was painted in cooler greens: Intense Blue, Indigo, Aureolin
and some French Ultramarine Blue. (John Lidzey)*

ABOVE *Many greens in this painting by Elizabeth Harden are cool and blue. These contrast effectively with the few slightly neutralized yellow greens.*

LEFT *A mixture of cold and warm greens merge into green / yellows in this illustration by Elizabeth Harden. All of these colors may be mixed from other hues without the necessity of resorting to the use of proprietary greens.*

MIXING BROWNS

Browns can result when colors from opposite sides of the color wheel are combined. When they are mixed most reds and greens will produce browns as often as red and blue will, in spite of orthodox color theory. Try, for example, French ultramarine blue and cadmium red, which, mixed with a little water, will produce a brownish mix.

WARM BROWNS

Cool browns are greenish, and warm browns are reddish or yellowish. Good warm browns can be mixed using a base of yellow ochre. Using this color with vermilion will result in a warm, sunny orangish-brown. Cadmium red with a small amount of indigo also results in a pleasing warm brown. Other combinations of colors are used here to show alternative results.

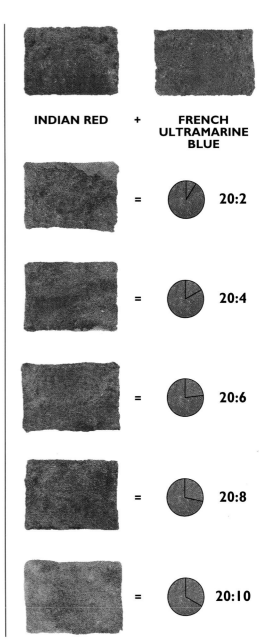

INDIAN RED + **FRENCH ULTRAMARINE BLUE**

= 20:2

= 20:4

= 20:6

= 20:8

= 20:10

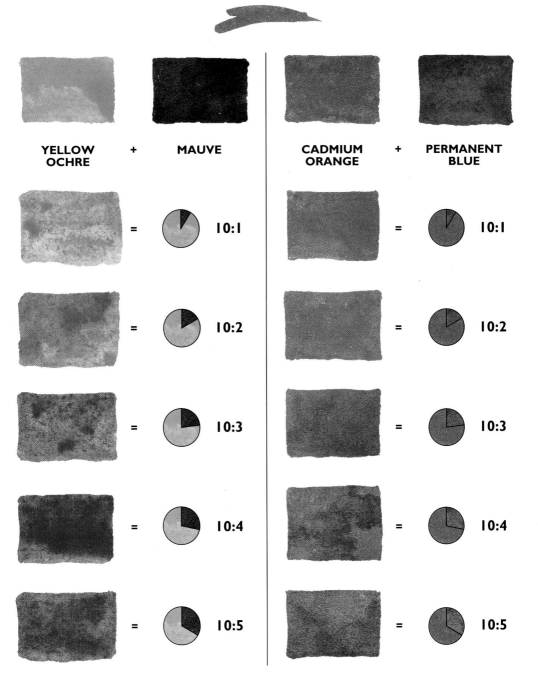

YELLOW OCHRE	+	MAUVE		CADMIUM ORANGE	+	PERMANENT BLUE	
	=	10:1			=	10:1	
	=	10:2			=	10:2	
	=	10:3			=	10:3	
	=	10:4			=	10:4	
	=	10:5			=	10:5	

MIXING BROWNS

COOL BROWNS

Brown is an easy color to mix. Sometimes an unintended brown will result when you are experimenting to mix another color. When you are out on location, winter landscapes can be fascinating to paint using the wide variety of brown hues that can be mixed from a watercolor palette.

Reds and greens mixed will almost always produce a brown. Using more green than red usually results in a cool greenish-brown. Sap green and permanent red will produce a cool, greenish-brown, as will viridian and cadmium red. Try also the combination of burnt umber and cerulean.

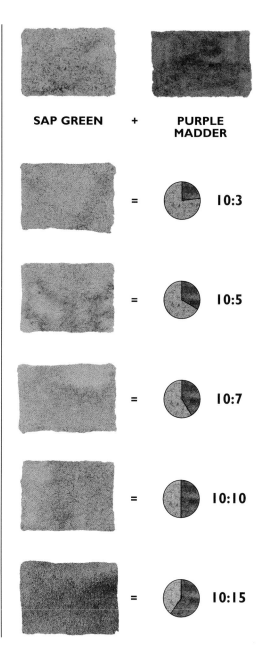

SAP GREEN + **PURPLE MADDER**

= 10:3

= 10:5

= 10:7

= 10:10

= 10:15

SCARLET VERMILION	+	PAYNE'S GRAY			VIRIDIAN	+	CADMIUM RED
	=	10:3				=	10:1
	=	10:5				=	10:3
	=	10:7				=	10:5
	=	10:10				=	10:7
	=	10:15				=	10:10

BROWNS IN STILL LIFE BY CANDLELIGHT

This arrangement shows a subtle range of colors from pale yellow/browns through to rich, cool blue/browns. The warmest color is shown in the halo of the lit candles, and it is almost exactly the same as the color of the rim of the jar on the right. The coolest brown may be

14 **cadmium yellow deep**
6 **cadmium red**
trace of French
ultramarine blue
standard dilution

7 **burnt umber**
7 **French ultramarine blue**
2 **cadmium red deep**
4 **yellow ochre**
strong dilution

11 **cadmium red**
3 **cobalt blue**
3 **cadmium yellow deep**
3 **yellow ochre**
standard dilution

11 **carmine**
4 **indigo**
3 **cadmium yellow deep**
2 **French ultramarine blue**
strong dilution

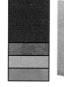 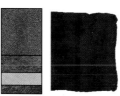

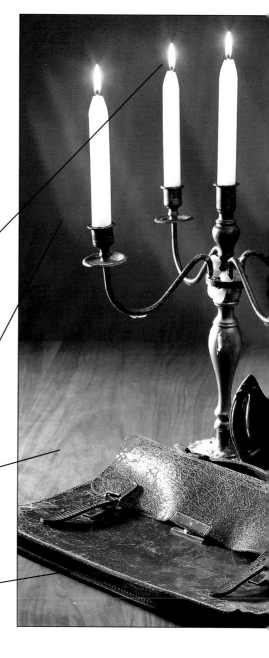

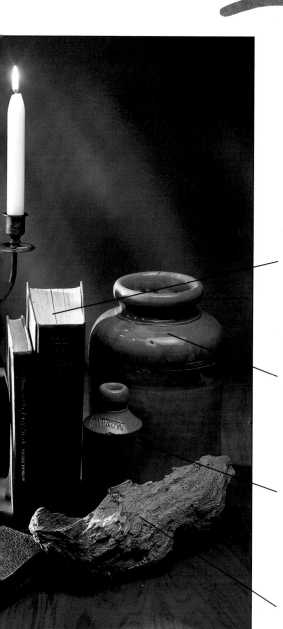

found at the bottom of the briefcase which contains some violet in the mix.

Many proprietary brown and brownish colors are available from art stores, but for the purposes of this demonstration most of the hues of brown have been made up from other colors.

15 yellow ochre
2 cadmium red
3 Payne's gray
very weak dilution

16 vermilion
3 yellow ochre
1 French
ultramarine blue
standard dilution

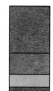

11 carmine
5 indigo
3 cadmium yellow
deep
1 French
ultramarine blue
weak dilution

10 alizarin crimson
5 French
ultramarine blue
2 cadmium yellow
deep
3 yellow ochre
standard dilution

GALLERY – BROWN

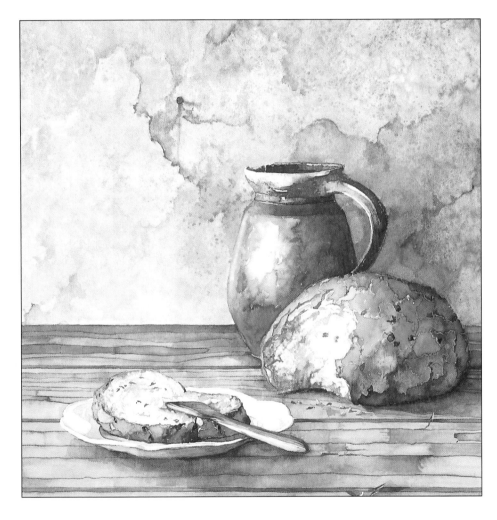

ABOVE *The range of subtle browns in this lovely still life by*
Crin Gale was created with just a few earth colors plus violet
and blue. The bread was painted in mixes of Raw and Burnt
Sienna and Burnt Umber, the jug in Burnt Umber and
Alizarin Carmine, while the background was painstakingly
built up from Cobalt Blue, Raw Sienna, Indian Red
and Burnt Sienna.

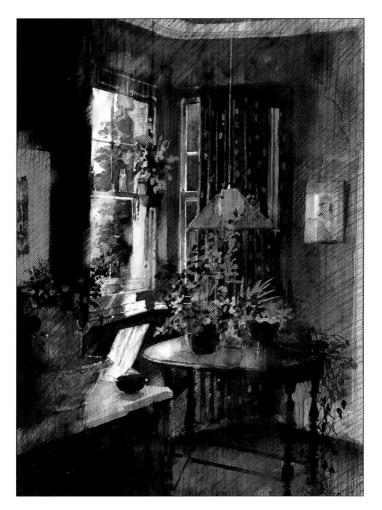

ABOVE The cool blues in this painting provide a contrast to the browns of the walls, furniture, curtains, and floor. These browns were mixed from Yellow Ochre, Cadmium Red, Payne's Gray and French Ultramarine Blue with thin washes of Indigo over the top. Because especially low-toned colors were required, a cross-hatching of black conté crayon was laid over all of the shadow areas. (John Lidzey)

MIXING NEUTRALS

Mixing a true black from just two watercolor hues is impossible, yet mixtures of three or more colors in sufficient density can produce a near black, although it will not have the quality of an ivory black. For example, vermilion, ultramarine blue, and cadmium yellow can be combined, with a little water, to produce an effective greenish-black. A number of warm and cold grays can be produced by mixing two watercolor hues together.

WARM GRAYS

Warm grays will result from mixing earth colors with blues. The warmth of the blue will affect the warmth of the resultant gray. Careful mixing is required. If you use too much earth color, the "gray" will become a brown.

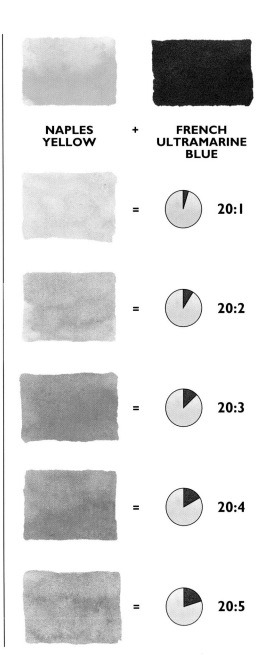

NAPLES YELLOW + **FRENCH ULTRAMARINE BLUE**

= 20:1

= 20:2

= 20:3

= 20:4

= 20:5

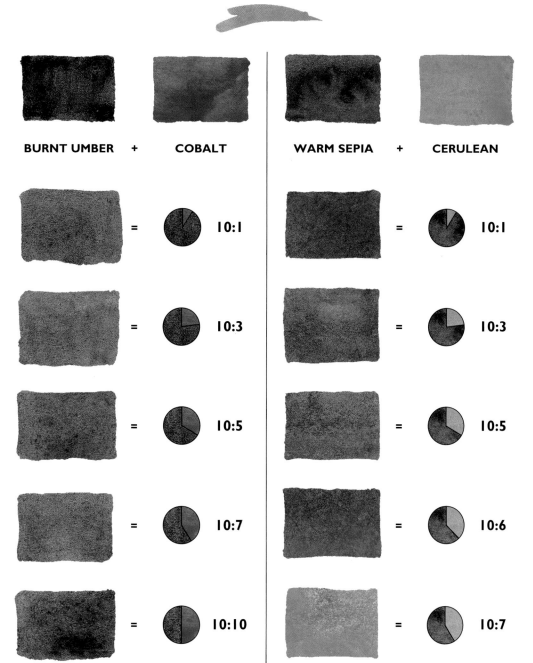

BURNT UMBER + COBALT WARM SEPIA + CERULEAN

= 10:1 = 10:1

= 10:3 = 10:3

= 10:5 = 10:5

= 10:7 = 10:6

= 10:10 = 10:7

MIXING NEUTRALS

COOL GRAYS

Like warm grays, the best cool grays come from a combination of blues and earth colors, although complementary colors, such as viridian and purple madder, will sometimes combine to make a good cool gray.

The proprietary color neutral tint can also be warmed or cooled with reds and blues to make a satisfying range of grays. Some alternative mixes are suggested here.

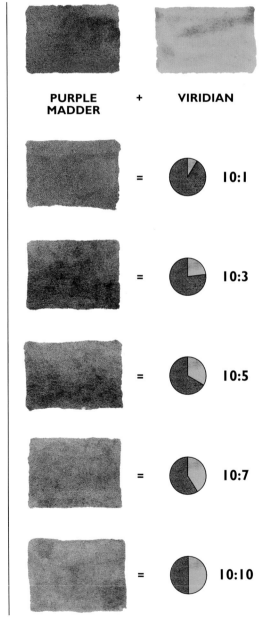

PURPLE MADDER + **VIRIDIAN**

= 10:1

= 10:3

= 10:5

= 10:7

= 10:10

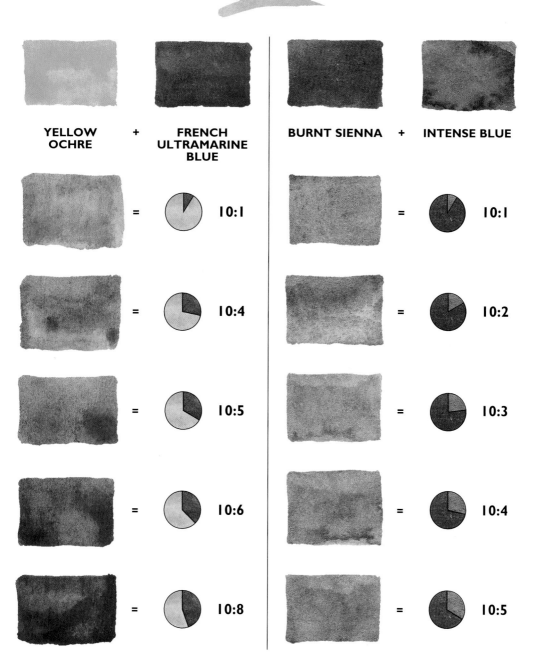

YELLOW OCHRE	+	FRENCH ULTRAMARINE BLUE		BURNT SIENNA	+	INTENSE BLUE
=		10:1		=		10:1
=		10:4		=		10:2
=		10:5		=		10:3
=		10:6		=		10:4
=		10:8		=		10:5

USING A LIMITED RANGE OF COLORS

The previous pages of this book have been mainly concerned with the problem of matching your paints to the colors in the subject. It is, however, quite possible to produce paintings in which the colors do not match those in the subject at all. Limiting the number of colors in your palette can be a part of this process.

A highly colored painting that matches exactly the colors in the subject can often be less satisfying than one completed with a reduced color range.

PAINTING WITH TWO COLORS

Find a suitable subject in the garden and try to produce a small painting in just two colors. Flowers and foliage could be painted in indigo and aureolin perhaps; or a garden wall

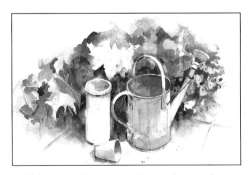

These two colors work well together, without being true to the original colors.

and foliage in vermilion and monestial blue.

Mix your colors so that they work well together rather than attempting to match the colors in your subject.

PAINTING WITH THREE COLORS

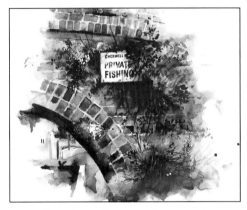

Just three colors can achieve a wide color palette.

The use of one extra color makes it possible to produce a wider range of colors. However, do remember to keep your mixtures under control. It is, for example, possible to produce a perfectly satisfying painting of a landscape with trees using mixtures from French ultramarine, burnt umber and cadmium yellow pale. Mix your colors with care, and use strong and weak dilutions of paint to achieve interesting tonal contrasts.